Donald Sultan

In the Still-Life Tradition

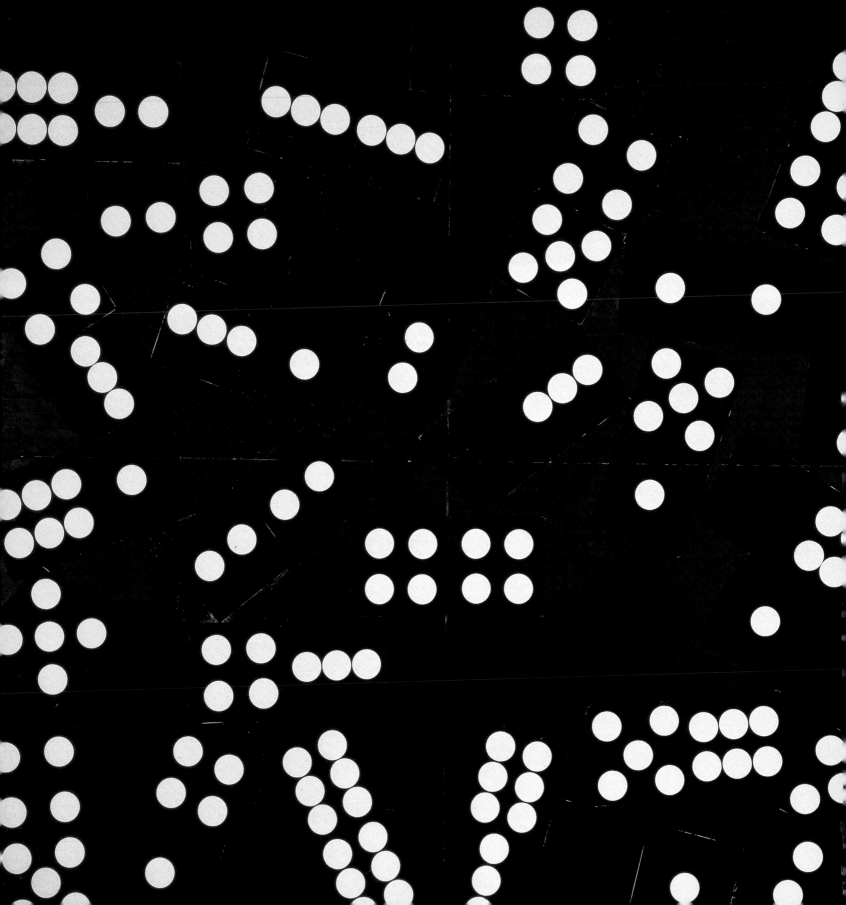

Donald Sultan

In the Still-Life Tradition

Essays by Steven Henry Madoff and David Mamet

The Memphis Brooks Museum of Art, Inc.
in association with the University of Washington Press
Seattle and London

Donald Sultan: In the Still-Life Tradition is organized by the Memphis Brooks Museum of Art and curated by Dana Holland-Beickert. The exhibition is circulated by Pamela Auchincloss, Arts Management.

Funding for the national tour and publication is provided by FDX Corporation.

Tour Itinerary

Memphis Brooks Museum of Art
Memphis, Tennessee
January 23–April 9, 2000

Corcoran Gallery of Art
Washington, D.C.
May 6–July 17, 2000

Kemper Museum of Contemporary Art
Kansas City, Missouri
September 16–December 3, 2000

Polk Museum of Art
Lakeland, Florida
March 31–June 3, 2001

Scottsdale Museum of Contemporary Art
Scottsdale, Arizona
June 29–September 9, 2001

For The Memphis Brooks Museum of Art:
Dana Holland-Beickert, Project Director
Jennifer Munn-Canfield, Graphic Designer

Library of Congress Catalog Card Number: 99-74793
ISBN: 0-915525-06-2

Designed by Susan E. Kelly
Produced by Marquand Books, Inc., Seattle
Printed by CS Graphics Pte., Ltd., Singapore

Cover: *Black Egg and Tomatoes, August 4, 1998* (p. 61)
Back cover: *Gladiolas in a Chinese Pot, December 2, 1988* (p. 37)
Frontispiece: *Stacked Dominos, October 28, 1994* (p. 51)
Page 10: *Lemon, November 28, 1983* (p. 25)

Distributed by
University of Washington Press
P.O. Box 50096
Seattle, WA 98145-5096

Contents

Foreword

Donald Sultan: In the Still-Life Tradition occurs at a most appropriate time. As we enter this new millennium we should reconsider the tradition of still-life painting. The representation of an assemblage of objects from the everyday world has fascinated artists and their audiences throughout history. Whether we consider the mosaics of antiquity, medieval illuminated manuscripts, Dutch seventeenth-century still-life paintings, or cubist compositions, the fascination remains constant. Donald Sultan's works fit perfectly in this tradition, but at the same time offer a springboard into the next century.

While Donald Sultan's subjects may appear ordinary, they become *extraordinary* by their representation. Fabulous oranges, lemons, and flowers dominate the surface with their brilliant colors and bold forms, demanding attention by virtue of their medium, size, color, and composition. It is as though Sultan has reversed still-life painting's hierarchy, while still maintaining an immutable foothold in the tradition. I know that you will enjoy the exhibition and accompanying catalogue and become as captivated as have we.

The tour and catalogue of *Donald Sultan: In the Still-Life Tradition* could not have occurred without the vital support of FDX Corporation. We are extremely grateful for their support and continued commitment to the arts and to building communities.

We are also indebted to Dana Holland-Beickert, Curator of Exhibitions at the Brooks Museum, for her role in initiating, organizing, and planning this important exhibition and publication. Any endeavor of this magnitude represents a labor of love, and we are most fortunate to have her enthusiasm, expertise, and commitment to this important project.

Kaywin Feldman
Director
Memphis Brooks Museum of Art

Curator's Acknowledgments

We publish this catalogue in association with the first touring exhibition based on the traditional theme of the still life in Donald Sultan's work. The project—both the exhibition and the related publication—began in 1996 when E. A. Carmean, Jr. (then director of the Memphis Brooks Museum of Art), and I made our preliminary visit to Donald Sultan's New York studio. After numerous refinements, the project has come to realization with this tour of the exhibition *Donald Sultan: In the Still-Life Tradition.*

The idea of an exhibition dedicated to Sultan's still-life paintings was of significant interest to me from the onset. I'm drawn into the paintings by their boldness, their confrontational directness, and their surreal quality. Sultan's still-life paintings, especially the large ones, are entrancing. Although derived from a traditional theme, these pictures challenge the thought process and require the viewer to reexamine any preconceived ideas of the still life. The enlarged, cropped objects that dominate many of the paintings invade the space of the viewer and possess the strength to lure you back into its imagery. Time seems to stand still as you find yourself staring into the colors and shapes before you, examining every subtle nuance.

There are numerous individuals who contributed to the success of this project. First I want to express my deepest gratitude to Donald Sultan for his invaluable suggestions and advice in the organization of both the tour and the catalogue. It has been a true pleasure to work with him. I further want to acknowledge Pamela Auchincloss and her associates for their role in the scheduling of the tour, the coordination of the catalogue, and all the endless tasks associated with that part of a traveling exhibition. Knoedler & Company in New York has also lent their support of this project and has assisted in several of the loans. The receptiveness and generosity of the lenders to the exhibition, and their willingness to part with their works for more than a year have made this presentation possible. I also wish to express my sincere appreciation to David Mamet and Steven Henry Madoff, who have been kind enough to include their

essays in this publication. I must also gratefully acknowledge the financial support of FDX Corporation, for without their commitment to the project, this catalogue would not have been feasible.

Last, but not least, the staff of the Memphis Brooks Museum of Art is to be commended for their roles. Kaywin Feldman, who assumed the position of Director in January 1999, has been extremely supportive of this project. I also wish to thank Kip Peterson, Registrar, for her hard work on the transportation and loan arrangements, and Jenny Munn-Canfield, Graphic Designer, for her valuable contribution to the design of the catalogue. Marilyn Masler, Associate Registrar, and Caroline von Kessler, Director of Public Relations, also contributed their editing and proofreading skills and overall support of the project.

Dana Holland-Beickert
Curator of Exhibitions
Memphis Brooks Museum of Art

Artist's Acknowledgments

I would like to thank E. A. Carmean, Jr., for beginning this exhibition and formulating its concept. I especially want to acknowledge the hard work of Dana Holland-Beickert, Pamela Auchincloss, Alexandra Muse, Claire Morris, Holly Summer, and Adrienne La Belle for making this exhibition happen. Their professionalism and attention to detail are greatly appreciated. I further want to thank Steven Henry Madoff and David Mamet for their contributions to the catalogue and Susan Sultan for her advice and love. A special thanks to all the institutions that have worked so hard to fit this exhibition into their schedules and present it to their public.

Donald Sultan

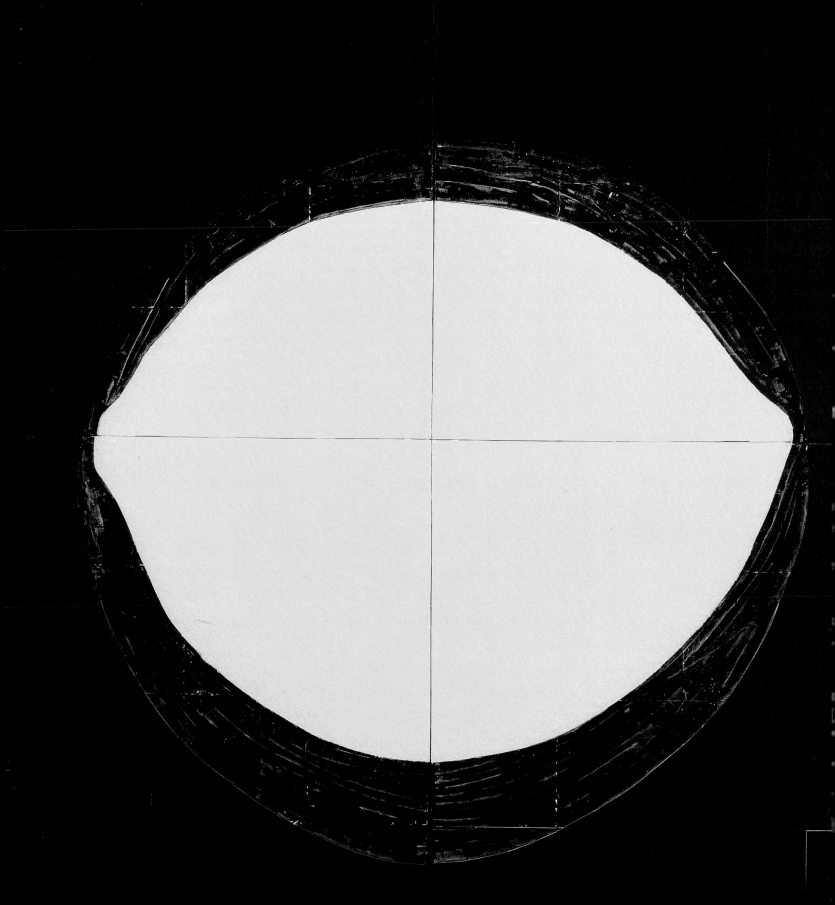

Still Life: Picture Machine

Steven Henry Madoff

In the jewel-case light of the picture, the lemon sits. Its skin weighs. Its flesh glows from within; evidence that nature's bounty is a distribution of miracles. For those, at least, who can afford such miracles at their tables. The picture proposes that one of light's properties is to enumerate, as if seeing were an instrument of arithmetic, so that we may count each object brought forth from the larder. Now look, the image suggests, and wonder at the sumptuousness of these parts: not only the outsized cup, as if carved by a sunbeam and ornamented with gold, that gives Willem Kalf's painting its name, *Still Life with a Nautilus Cup* (fig. 1), but also, there among the trappings, the lemon, its skin half unwound, its fruit faceted, gemlike, to tell you, viewer, that he who can afford this picture owns such things, in the light of faith, from the wealth of his own work.

Fig. 1 Willem Kalf, *Still Life with a Nautilus Cup*, 1660. Oil on canvas, 25¼ × 22 in. Museo Thyssen-Bornemisza, Madrid

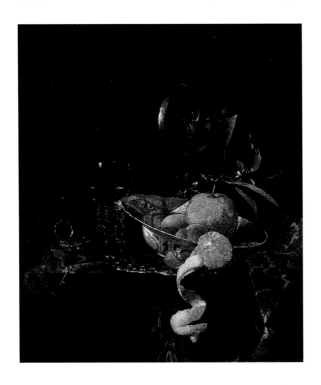

In still life, the arrangement of domestic objects means that they can be held in a hand, moved here and there to become a composition. They are inventory and invention, over which the artist and his patron hold power. They are in the dominion of realism, bound to the notion that description is a gift of fact. Though fact may be, like the objects in the picture, instrumental, put to use. So the great flourish of sixteenth-century Dutch still-life painting was, in the argument of its Protestant and bourgeois beliefs, an emblematic art of material plenty: meticulous, triumphal, yet, in the *vanitas* tradition, an assertion of time's scythe—an allegory taught on a table top with a skull and burning candle, a flower with petals falling or a soap bubble floating, frail. Each one is about brevity. Each one holds more gravity than all the tonnage of life's trophies.

You can hear that dark note in the Dutch name, *stilleven*, life that is not animate but stilled. Its transitory sense echoes back to the Greeks and Romans whose mosaic art first snared domestic things and laid them out in flattened space—pieces of fruit or crumpled paper—and called them, from the Greek, *asarotos oikos* (unswept house) or *rhyparographos* (images of litter).

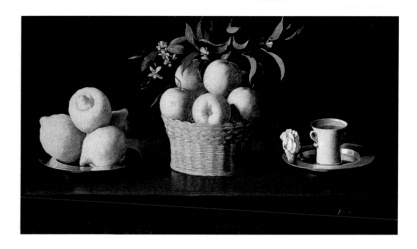

Now another picture, a great jump in time, and in that leap, in the contrail of this jet surging forward, imagine the history of three centuries of still life: from Flanders in the 1550s, when Pieter Aertsen first pushed his religious subject matter to the back of his paintings so that the most common things could hoard the front: a tumult of vegetables and meat. And here are the exacting scientific fetish flowers exquisitely detailed by Jan Brueghel the Elder, called Velvet Brueghel, painted for his patrons as the sixteenth century ends. Now tumbling in this image-wash, back to the fifteenth century, Hans Memling's vase of flowers on the verso of a portrait, blossoms to evoke the purity of the Virgin.

Or rush ahead again to the last years of the 1600s, to Caravaggio, whose revolt against the lavishness of the Roman Church is seen in the simplicity of his *Basket of Fruit*, with its drama of lightness and dark. How spare it seems beside the heaped boards of the Northern Europeans. Caravaggio, of whom a contemporary writes, "It required of him as much craftsmanship to paint a good picture of flowers as of figures," which is a canon blast that collapses the traditional hierarchy and raises *nature morte* up beside religious art and history painting. Zurbarán is also here; so internal an artist and Caravaggesque. Consider his own image of fruit, his *Still Life with Lemons, Oranges and a Rose* (fig. 2), which, too, is of a different order from the Dutch: his bounty not massed but winnowed, his fruit almost rising, lifted by light, its luminousness scrubbed clean of the worldly.

Zurbarán's is a painting of the Counter Reformation, rigorous and reduced. Yet in this same pulse of time, Rubens' supremacy in the Baroque style rules with

grandiloquence; a sensuous exuberance pushed by his followers' hands toward the decorative that seems becoming in the next century, the eighteenth. Still lifes cover furniture, are placed above doorways. Even Chardin's work, so masterful yet as soft to the gaze as plumped down cushions, is used for a fireplace screen, as if the still life has itself been absorbed into the tableaux it pictures. And only then in the nineteenth century, with Goya and Manet, does something break. Goya's blood-heavy cuts of meat draped one on the other with the perfect off-handedness of casual violence. Manet, whose brush captures the immediacy of a world changing as the 1860s accelerate into our own century. From his hand, in a few strokes, come stalks of asparagus, lithe, fresh, as if to say here is the rude candor of modern life.

The contrail is enormous, the paintings awash: the Flemish, the French, Italians, Dutch, Spaniards, the Germans; the schools of floral painting; the allegorical codes invented, rigidified, then lost in the historical stream. What has happened is this: the point of still life has changed. With modernity, its purpose shifts from serving Christ's church and the moneyed class to serving painting itself and the artist's temperament. Here is Van Gogh's *Lemons on a Plate and a*

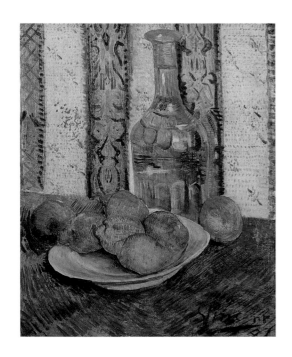

Carafe (fig. 3), a vibration of a few recognizable forms so densely put down, so willed and ecstatic, that they are about the punishing beauty of paint and the mind that sees it so. The code is hugely personal, neither more nor less than the signs of Church or State, but other. And with this shift, it is no surprise, as Meyer Schapiro says, that "the painter's habitual selection comes in time to stand for the artist and is recognizably his." Schapiro is speaking specifically of Cézanne, who is here, too, in the great stream. His apples, pears and wine bottles, tables and cloths—traditional furnishings of the genre. Yet in the countless refinements of his motif, our own modernism is given direction: a psychological art in whose objects is held the whole struggle of rendering what the mind apprehends through time and feels through the eye. From this, the Cubist still life, which presses the notion that art is as

13

much about its workings as its subjects; that the avant-garde carrying out this program does so to shock convention—to borrow David Foster Wallace's words, to be "a broom to the system."

But now the leap ahead, from Kalf's lemon to this one, more than three hundred years on. Another glass and table, a lemon's peel drifting down like citrus ribbon. Like Kalf's and a thousand other specimens of the genre, a sense of fealty: he who prospers. Yet here the image is flattened out, spare, formally hierarchical. Roy Lichtenstein's *Still Life with Glass and Peeled Lemon* (fig. 4). You can hardly call it delicious, can you. The glint and succulence have given way to something far

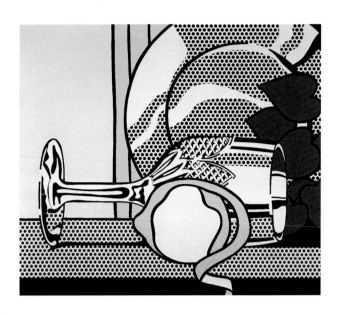

Fig. 4 Roy Lichtenstein, *Still Life with Glass and Peeled Lemon*, 1972. Oil and magna on canvas, 42½ × 48¼ in. Courtesy of The Helman Collection, New York

less sensuous: a visual essay on the means of the image, on the economy not so much of social class (though this is implicit) but of paint and line. The intricacies of the lemon's flesh are hardly necessary for so reliable a sign. Color is no more than a rudimentary exchange with the viewer: yellow = lemon. It is not felt, it is equated. What we learn is that still life is a tradition used now as a picture machine. It's an apparatus to pump out propositions about what painting is. At least in the hands of someone as smart as Lichtenstein, whose work epitomizes the lesson of Pop art that the world is utterly transformed by commerce. There is no need to shock the system, and Pop hardly did.

Everything in postwar America has the gleam of the packaged good. The agony of the Second World War, the outpourings of angst, are replaced in the early '60s by a world in which deep feeling gives way to the glancing glamour of products, driven by the euphoria of the Kennedy years, of America's global rise. Lichtenstein's crisp, brightly colored image is the right package for the times, this precision-built parcel. What does it contain? An index, a still life of artfully arranged references: about the genre of still life itself; about an absence of depth in the image that tips its hat to Cubism and collage and says that the painting is less about pretending to be a window through which you look and more about the window itself. And it is about the chameleonlike fluidity of

style: how Lichtenstein's benday dots quote from the look of comic strips, which are then imposed on any other style, any other history, and become his own style, his own surface. His benday dots work like a trademark, the instantly recognizable package, the perfect product. They tell us immediately that his picture is about being a thing that pictures. A very modernist thing, indeed, obsessed as modernism is with its techniques, its processes, its materials. But then the story of modern art could be told as the story of still life. The self-consciousness of modernism so visible in Lichtenstein's painting had become by this point the condition of all advanced still life—and would continue to be.

Which is how we get to these paintings, Donald Sultan's. It is part of his story that his own lemons came about as a response to a small Manet of the same subject, which Sultan saw in a retrospective at the Metropolitan Museum of Art. The line is long—not for the show, but for the tradition. Sultan enters here. The fruit beckoning. Now, as our century winds down, against a black so deep that it is the pure idea of backdrop, his lemons appear to thrust forward. They are enormous. The picture is eight feet square. Echoes of ovoids, spheres, nippled shapes, the weight of flesh, of fruit, a presence. Now look again. The sense of product, of industrial goods, invades the image. It *is* the image. If you step close enough, first looking out for the watchful guard, you can smell it: the picture's black background is tar, a sealed package. Its wrapping is blunt matter, but it also enwraps an idea, the Pop notion that culture prefers sensation to sentiment, prefers surface to depth. It carries its modernist legacy forward, fascinated with its material identity, with its means for representing.

A picture about a thing that pictures. *Lemons, April 9, 1984* (fig. 5). But we're far from done with this tar; and there are the vinyl tiles the tar is spread on and the plaster that is the ground, the body, of the lemon's forms. Sultan's picture-package contains its own freight of emblematic signs as codified as Dutch *vanitas*, but it is more about these material properties than about the subjects

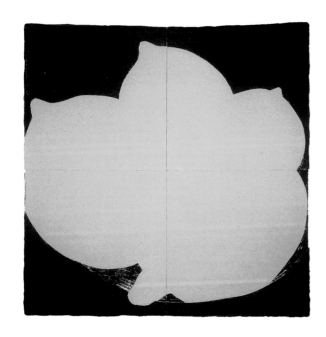

Fig. 5 Donald Sultan, *Lemons, April 9, 1984.* Tar, oil, and plaster on linoleum over masonite, 96 × 96 in. Private Collection

that emerge. Richard Serra's heavy abstract shapes, monumental accretions of oil stick, are in the weighted blackness of Sultan's tar. There, in the industrial tiles, echoes call from Donald Judd's notion of "obdurate materials," which was Minimalism's rallying cry: the *ding an sich*, the unalloyed thing itself of matter. And the grid of those tiles repeats no less than the chanted repetitions of pure geometric forms in Minimalist sculpture. Sultan's plaster: its physical way of filling a shape pushes the object forward, turns it into an icon, which is what happens to the idea of still life when Warhol focuses on an object, isolates and magnifies—Marilyn silk-screened, the sculpture *Brillo Box*. Or plaster again, in the hands of Claes Oldenburg, whose early sculpted still lifes of food are farther out as a reference, but are in the inevitable orbit of Sultan's eye and interests. No less for Oldenburg's wickedly enlarged forms.

Now look at these other pictures by Sultan. The images are invariably centered on the plane. They are enlarged, often cropped (add photography to the underlying debt of influence). From the grit of tar, a svelte surface is built, and the forms themselves, so reliant on black to set them off, have a purchase on elegance that resides in the simplicity and flatness of the shapes. Color, in fact, is subordinate to drawing; used less for nuance—to mold a form in space out of preternaturally graded hues, as Cézanne did—and more for the percussive impact of its graphic charge. *Flowers and Vase, August 12, 1985* (p. 29): its silhouette of green and terra cotta playfully abuts solid form against the broken mass of leaves. There is darkness against light, curves against the rectilinear rigor of the tiles. The grid and the image accommodate a two-headed beast of postwar art—abstract Minimalism and the reprise of figurative painting. The tension (and self-consciousness) is explicit, and the physical heft of the picture, along with the large-scale drawing, thrusts into the viewer's space.

You see it again and again. In the stark sumptuousness of *Oranges, February 27, 1987* (p. 31), whose strategy is to interpolate orange fruit and fruit shown as velvet negative space. Sultan invokes Man Ray, whose Rayographs were the most whimsical little still lifes: solarized black-and-white photographs that reversed the order of light, negative forms where the eye naturally sees positives. But then black and white are often plenty for Sultan. In *Gladiolas in a Chinese Pot,*

December 2, 1988 (p. 37), in *Hollyhock, January 17, 1991* (p. 43), the reduction to this spare palette is a showcase for the drawing itself. In each of these paintings (and many others; it is intrinsic to the way Sultan works), the drawing lures abstraction, pulls it into the figurative shape: the serpentine forms on the pot, the labile stack of black, loose oblongs that say "hollyhock." And then there is the cropping at top and bottom that emphasizes the age-old message of the *nature morte* painter, that he moves the domestic thing as he wants; he holds dominion. Only here, in Sultan's work, the still-life artist marshals a few means to enforce an effect of almost brutal mass. For all the elegance, there is something in the enormous enlargement that admits grotesqueness. The sense of the overwhelming plays out in the fact that anything so large that is stood too close to looms, becomes at its periphery unfocused, therefore abstract, ungraspable.

It is a curious strategy to take the intimacy of still life, that comfortable arrangement of the graspable, and turn it into the sheer physical mass, into the dominating thing. But in the historical stream, in the aftermath of Abstract Expressionism, of Pop and Minimalism, it has its pretzel logic. And how fitting, then, that Sultan's imposing package, so austere and lush, suggests this thing as property—shuttling us back to Dutch still life and its cozy material trophies. Only now, of course, the objects of the still life—the expensive flowers, the gilded goblets—are not so much the boast as the picture itself is: grand, seductive, to fill a wall big enough that only the bourgeois could afford it. There is no struggle, as there was once between earthly pleasure and a stern God. No, after all, this is art after Pop, where goods have taken on the power of a shallow but continual solace. It seems impossible that the warning, the mortal stress of the *vanitas*, could exist in the vocabulary of still life today.

Yet for all the moral and stylistic shifts in the conjugation of still life, the lexicon has hardly changed. The genre is about repetition. The same objects again and again, even back to the Greeks, before still life was still life. The forms studied, invested in, a meditation. How much this was so with Chardin's countless, beautifully limp hares, his copper and crockery. Of Cézanne getting at the truth of nature a thousand times through an assembly of apples and folded cloths. Morandi no less, with his earthen palette and small legislature of bottles, tells

us through innumerable presentations, about the stillness of time in which objects become more than themselves, become talismans. The repetition in Sultan's pictures is no different—a selection of things, a way of working that comes to stand for the artist. Over and again, he uses the same space; the same materials; the same format; his colors unmixed in the stead of illusionistic ambient light. Flowers, fruit, vases, objects of the house; expiring things stilled, caught, yet now without an underlying homily.

But then, these pictures are of their times. Like Schnabel with his broken plates, like Kiefer with his straw and mud, in the early '80s Sultan found the need to reinforce the rich palpability of things on the picture plane after spartan Minimalism, after the ethereal abstractness of Conceptual art. In his more recent images of dominoes there is a metaphor—mine, not his—for still life: the play endless, the repertoire limited at heart, but the combinations mathematically huge, going on. What a curious turn that the physicality of these pictures was one pointer toward the installation art of the '90s that is surely, though oddly, a tributary off still life's swollen river. Not that there weren't purely sculptural precedents, from Picasso's absinthe glass to Duchamp's ready-mades, all the way up to Haim Steinbach's Formica shelves of detergent boxes that were made at the same time as Sultan's work. In this last decade, installation art has been a hallmark, as all sorts of unswept things have found their ways into tableaux small and large, from the scattered, abject dolls of Mike Kelley to the post-Pop collections of stacked six-packs of Cady Noland. It is as if still life has undergone this generative change, yet more protean, producing solid objects where once there were images alone.

Sultan's pictures—with their weight and scale, with their sculptural mass, with their polyglot references to the past—are a marker on that road down which still life goes. They're swept up now in the contrail as it twists, the picture machine pumping, as it moves along.

Donald Sultan Traveling Show

David Mamet

1. Alacazam

The curse of the artist is an insistent imagination. Few things, I find, lay it to rest—gambling, sex, the more physically demanding sports, dangerous pastimes, and, unfortunately, writing.

But one can only write creatively, I think, for short periods. After these spells of blessedness, one is left with the necessity of assessment and revision. One is left staring at oneself, caught somewhere on the scale that begins with resolution and ends with loathing.

How wonderful, I fantasize, to be involved with something outside of oneself —to paint, for example, or to draw. I have been trying to sketch now, for a while, and I do find it delightful. On the rare occasion I get a line right, I am thrilled. I wish I were a painter. I wish I were painting still lifes. I wish I were looking at that bowl of fruit all day, in ecstatic, limitless gratitude for its bottomless variety.

Or, perhaps, the painter just says, "Fine. I got to paint the pear."

But I doubt it.

I think it is not for nothing that we hear of this or that overly imaginative soul who, late in life, took to daubing.

For the necessary obverse of autonomy is doubt. And—at least to the fantasy of the amateur—the painter's doubt is resolved by the subject. This is what I see in great painting: "I am not making this up. Only I alone am escaped to tell thee."

There is a genre piece by Oliver Kemp, c. 1915: a Swell hunter and his rough-hewn guide float in a punt in the reeds. In the background is a moose. The sky is sick white-lemon. Its color is improbable, but I have seen that sky. But I didn't see it until after I had seen the painting. And I never saw the crook of the woman's arm over her head, as she nurses the child, till I saw it in Picasso; and

I never saw what are to me the now ubiquitous and sad building canyons till I saw them in Donald's work.

The thrill of sketching, to me, is the discovery of the gap between my preconceptions and the truth of the subject. How grand to be wrong. How grand to live in a world where one and one's own powers are revealed as charmingly inconsequent.

The motto of the magician is *abracadabra*. This is an Aramaic phrase, and means, "I speak, and it comes into being."

An allied ejaculation is *alacazam*, which, if we torture the root just a bit, might be said to mean, "I do not deceive you," which utterance, I think, approximates the artist's sentiment to donate or inflict his or her work upon the public.

There is, or there must be a meaning beyond the evidence of our traitorous, subverted senses.

As I age, less and less makes sense to me. I find that I am holding a colloquy not with the world, but with my preconceptions of it.

But how wonderful, upon the other hand, to be a painter.

2. Two Dachshunds

Eros and Thanatos would be the two dachshunds of somebody with a little too much time on his hands, or, alternatively, Freud's Zoroastrian Life-Forces ever at war. Well, Tolstoy tells us that there is no tragedy in life equal to The Marriage Bed, and there you have it. For, do these two forces not war, the momentary precedence of each empowering the other until blah blah blah. And the reverse of the medal for concision, for dedication to reality, is, in the artists, enlicensed furor and the love of chaos.

Oscar Wilde wrote that each man kills the thing he loves, and we have nodded sagely until we stopped to reflect and found that he had tortured the conceit. And Escoffier, had he lived, might well have written, "Each man eats the thing he loves"; and Henry Ford, "Each man puts the thing he loves into first gear." For none of these have any referent other than the exuberance of the utterer, and that is the other side of the coin—the artist, while confessing his or her humility under God, daring the (real or imagined) audience to kiss

his or her ass, and if they don't like it, they can go look at some other traveling show.

3. Donald Sultan

These are big paintings. Many of them are big paintings of small objects. Those quicker and/or less principled than myself might parlay these two spot-on observations into an invitation to dinner, or a Chair of some new and savage discipline at a liberal arts college, but I think I'm going to "just play these."

Do I like Donald Sultan's paintings? Yes. Is this the paltry limit of my Aesthetic Sensibility? Yes. In a perhaps unrelated aside, I even like Donald Sultan. In fact, I adore the guy. Why?

1) I like his paintings.
2) He is a Southern Gentleman.
3) He is raucously funny.
4) He is an odd duck.

Note that to my untraveled Northern Sensibilities, #4) may be none other than a reiteration of #2).

In addition to speaking with incision and perception, which causes the hearer to think that not Donald's but the hearer's own perceptions are skewed, his voice sounds like Bourbon and honey. So, you see, I am stuck on the guy.

When I am with him I never don't have a good time. We go out to dinner, or have a drink or two, or hang out. He always comes to previews of my plays and rough-cuts of my films, and *invariably* likes them. I, of course, search his face for the merest microscopic hint of an amiable falsity, BUT I DO NOT DISCOVER IT. I tell myself that, therefore, it does not exist and that this extraordinary fellow actually likes my work.

Additionally, I suggest, time to time, a project of some great or less bizarrity—a collaboration on a children's book, a film or theatrical poster, a disquisition on the Bar Mitzvah—and he always says, "Yes." He, equally, responds, and I have found words of mine, translated into Japanese, in a book about his paintings of playing cards, and in various catalogues (*vide ipso*).

I have also, for years, found myself dressing like him, the man who, with his Olympian calm and self-assurance, brought back the cardigan. But I cannot think as he can. My accent, with its "dese, dem, dose," is closer to Yahoo on the Pavement, and, of course, I cannot paint at all, which, you will allow, is an acceptable if not inspired segue.

I am not smart enough to say anything about these beautiful paintings, but I *am* smart enough to know it. *Shantih*.

Catalogue

Lemon, November 28, 1983

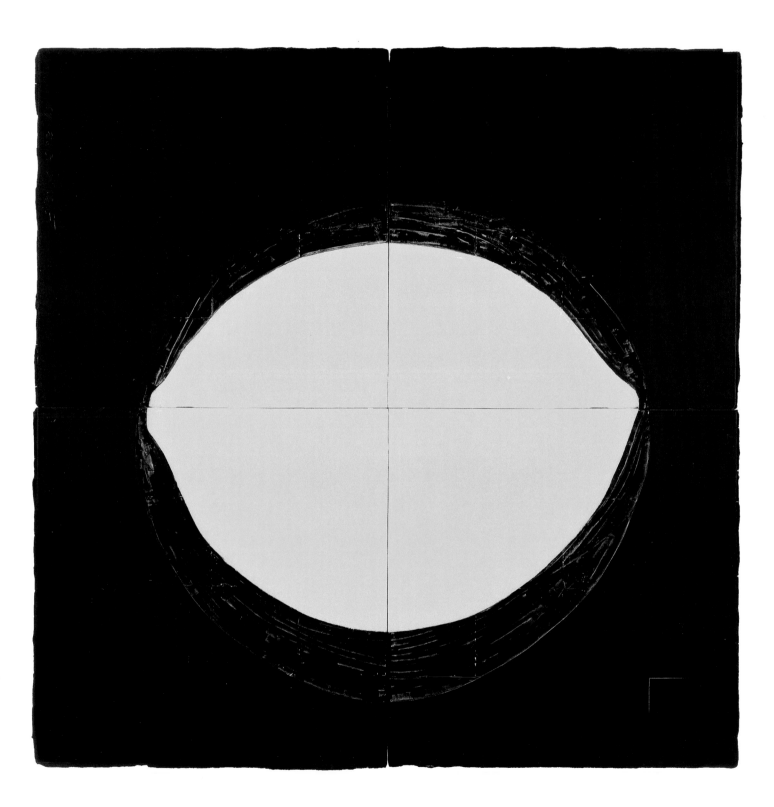

Four Lemons, February 1, 1985

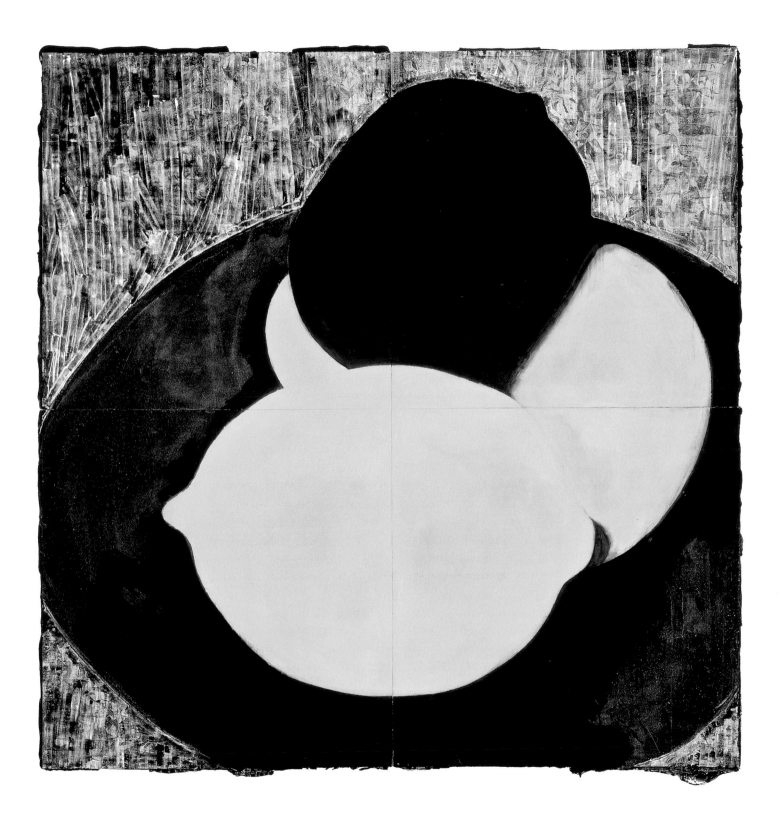

Flowers and Vase, August 12, 1985

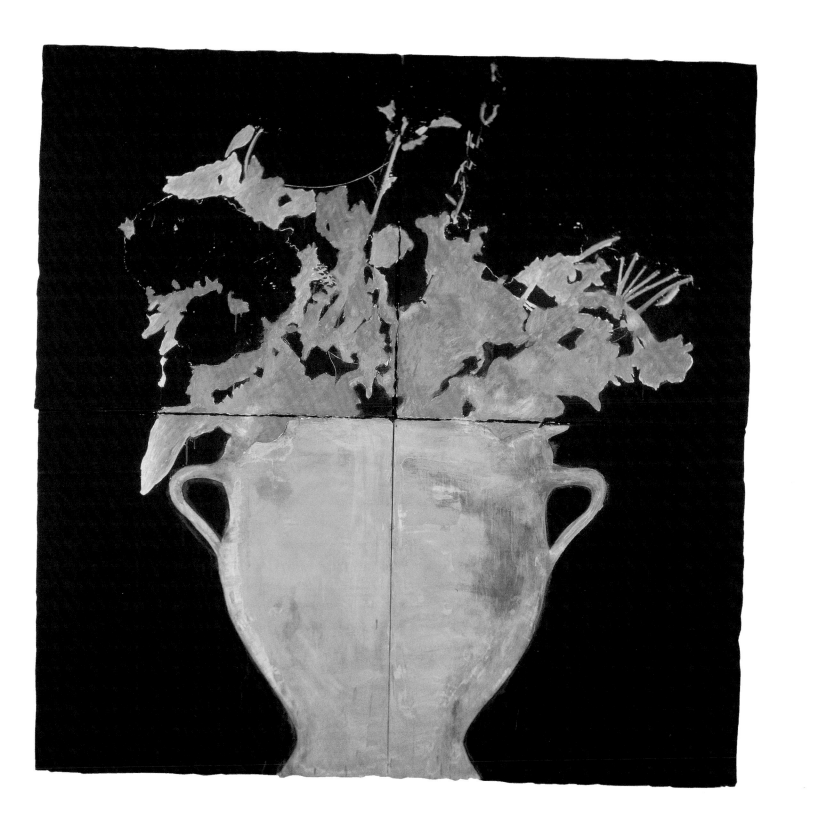

Oranges, February 27, 1987

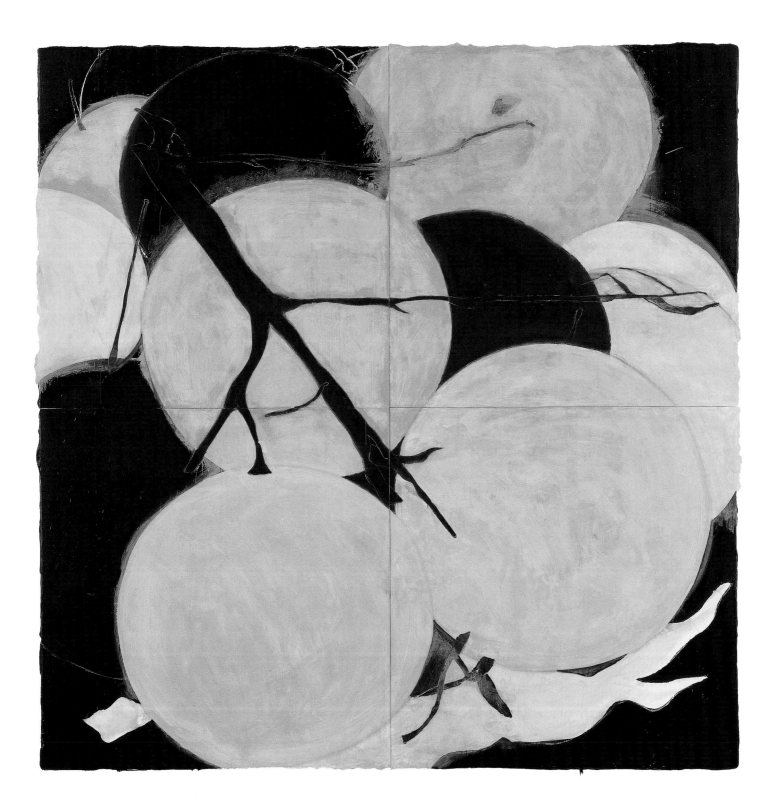

Three Molding Limes and a Clementine, February 19, 1988

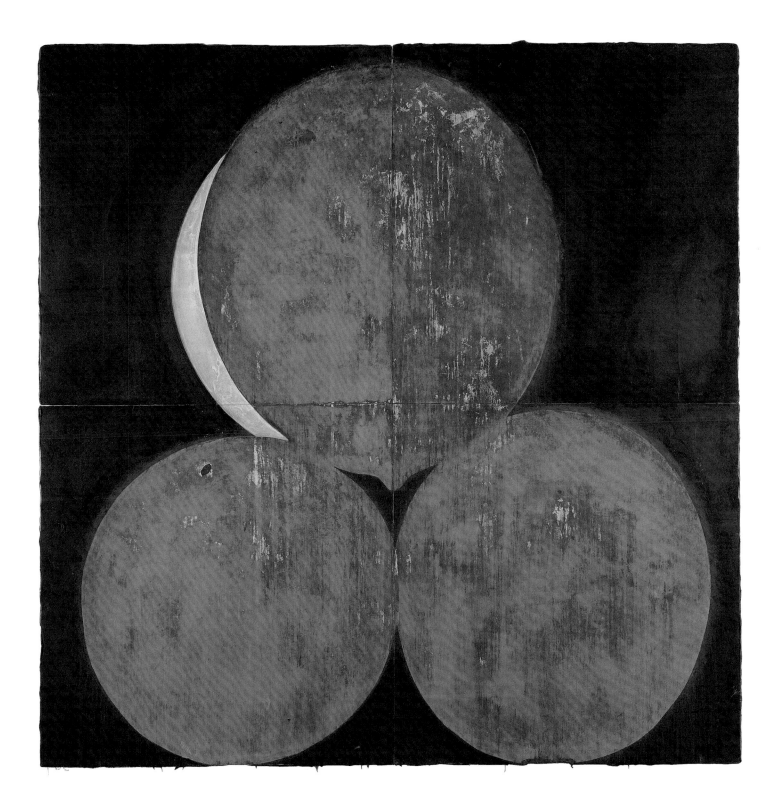

Matisse Flowers and Vase, September 23, 1988

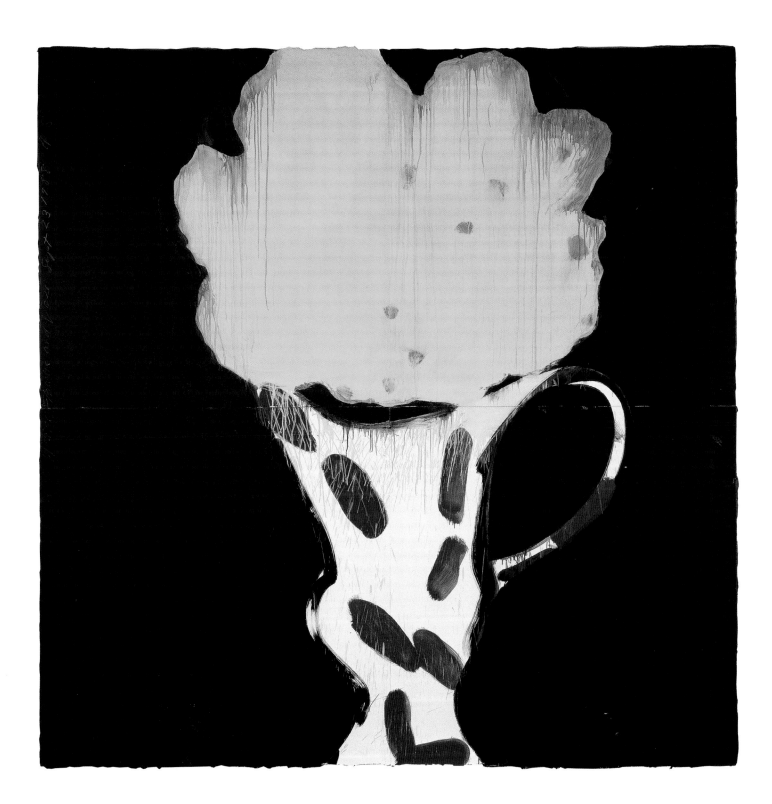

Gladiolas in a Chinese Pot, December 2, 1988

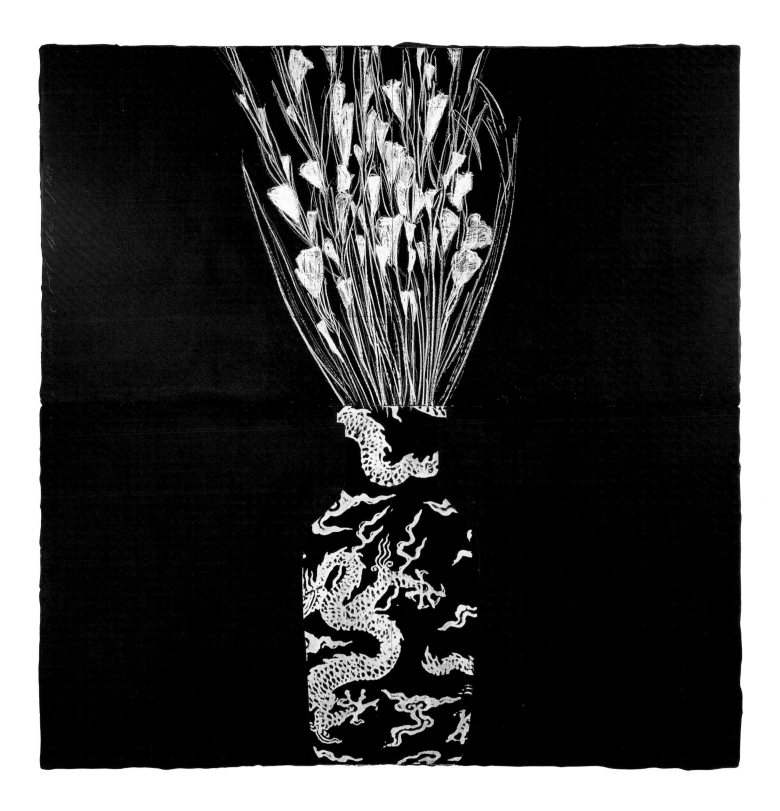

Black Roses in a Black Rose Vase, February 2, 1990

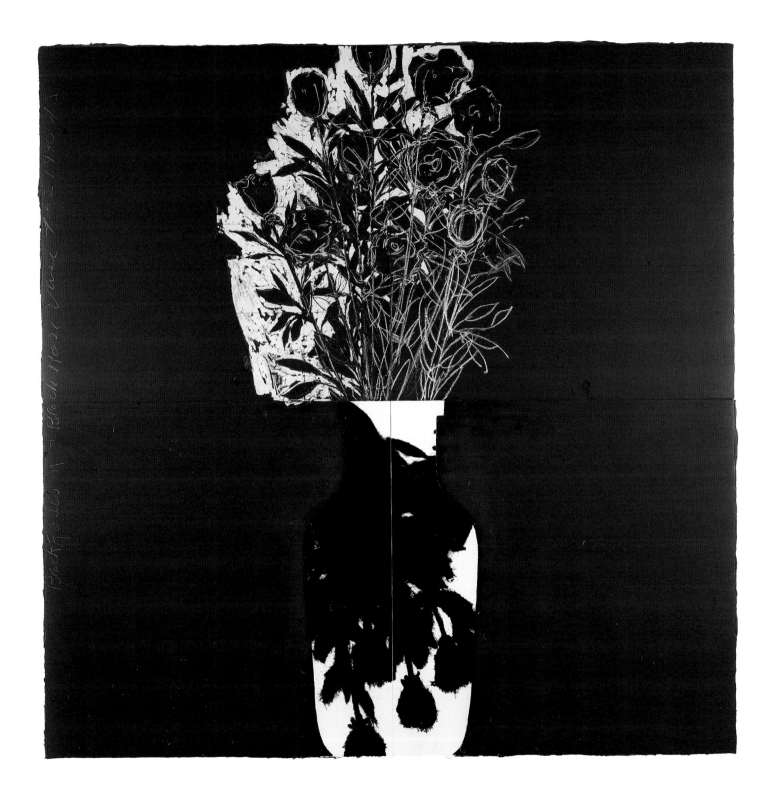

Domino, June 8, 1990

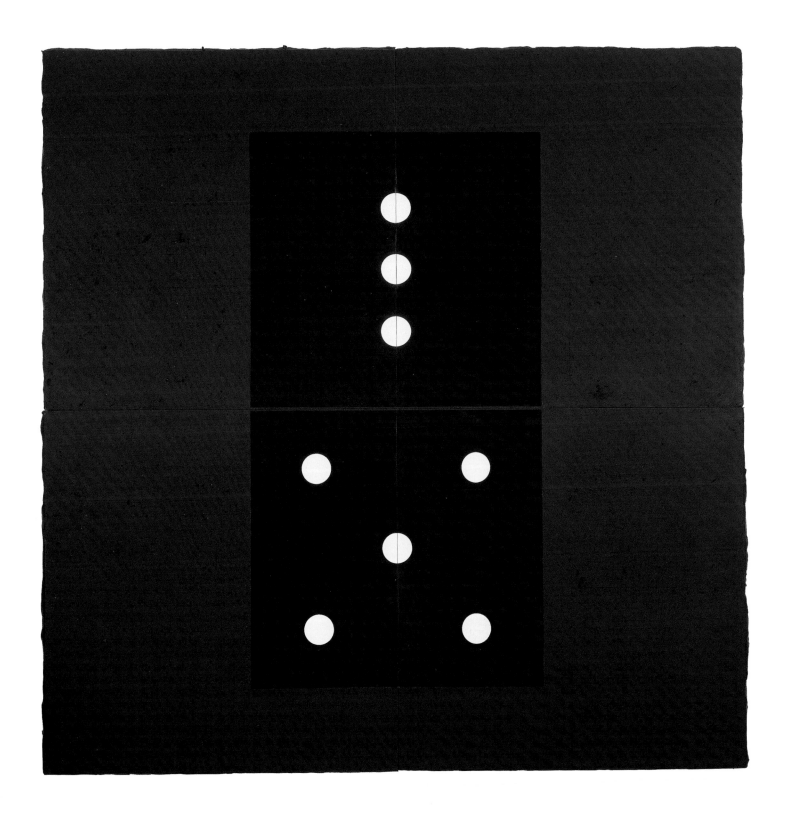

Hollyhock, January 17, 1991

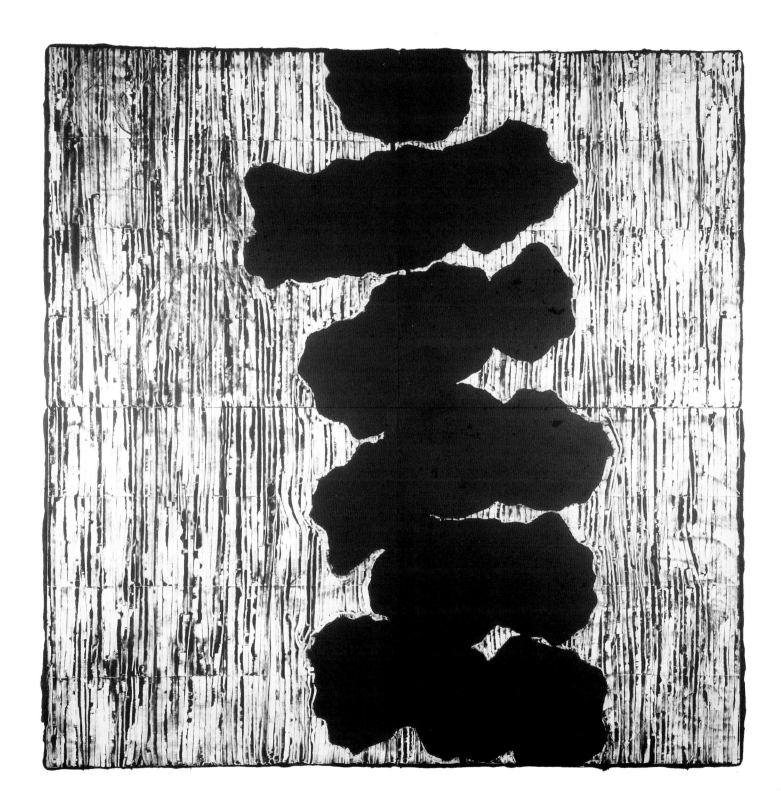

Double Vase, March 11, 1992

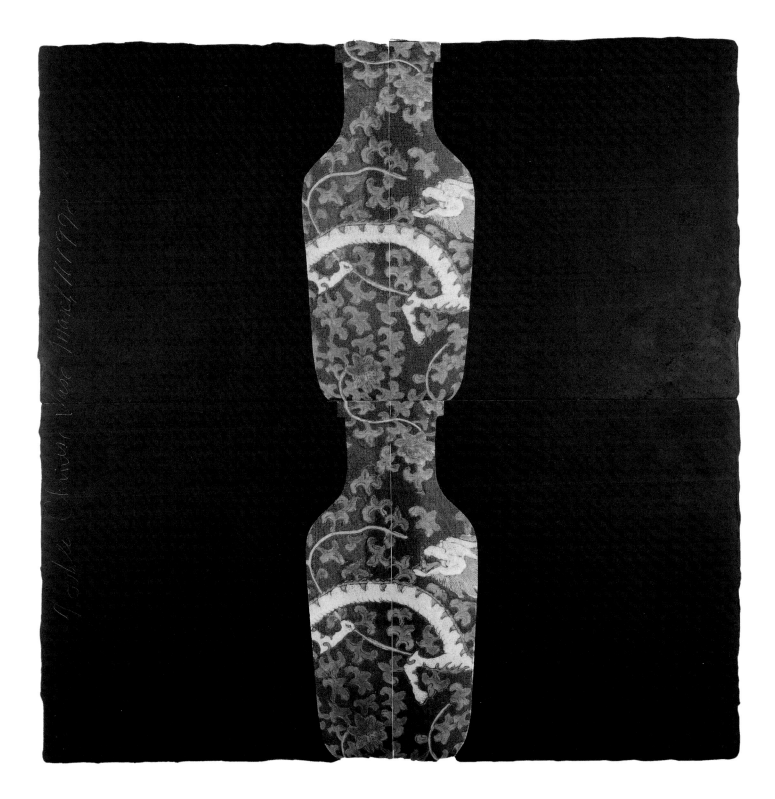

Oranges in a Pot, April 5, 1993

Spike Acanthe, July 5, 1993

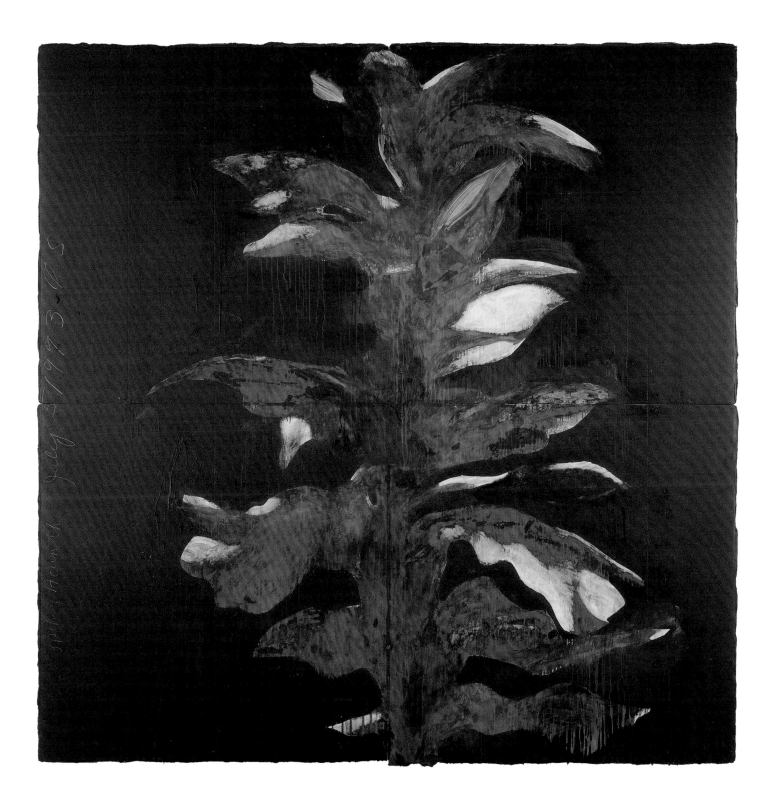

Stacked Dominos, October 28, 1994

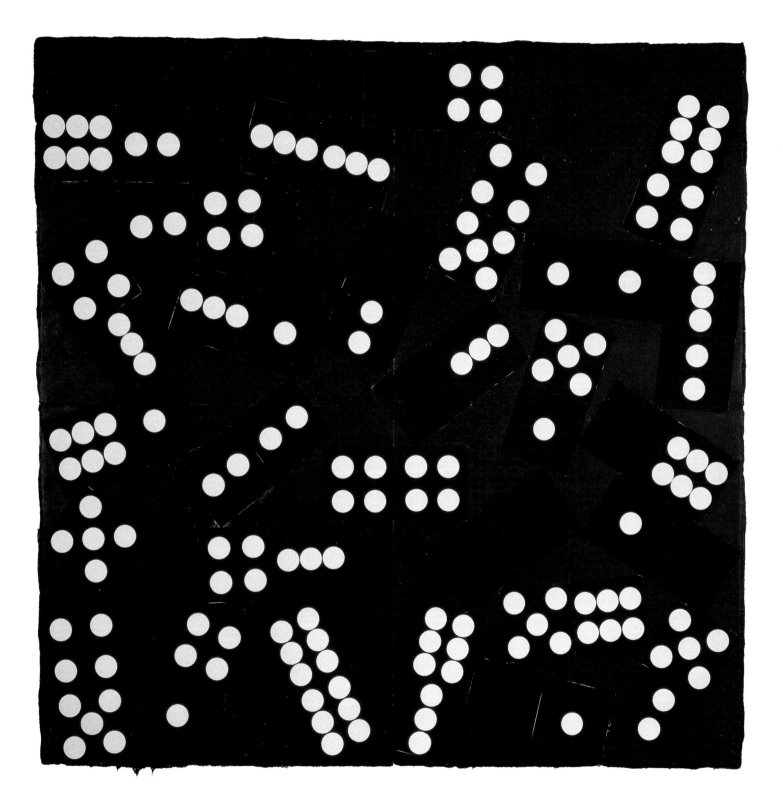

Packed Vases, January 31, 1995

Four Buttons, July 29, 1995

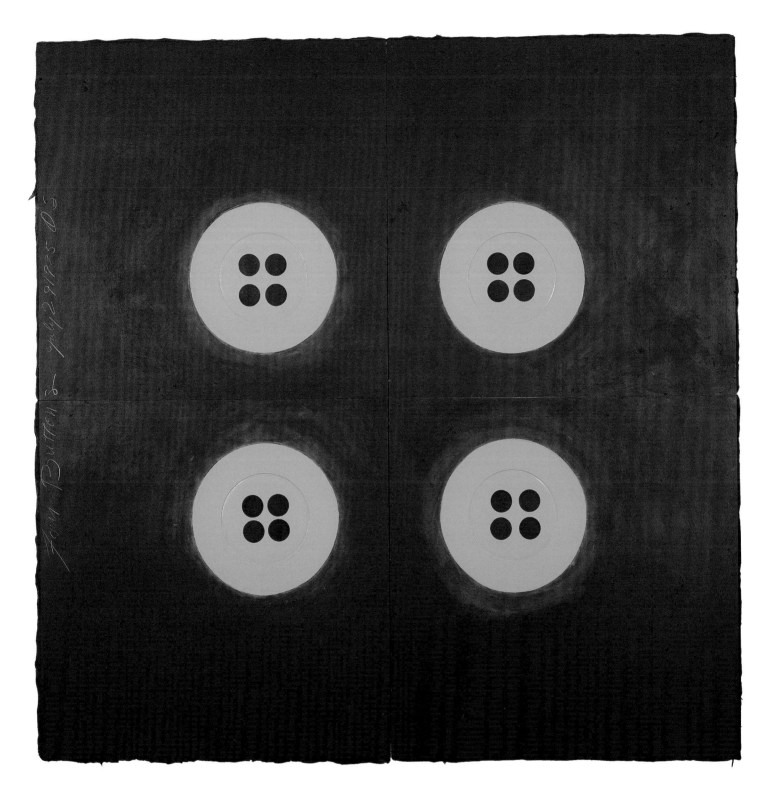

Nine and Eleven, August 16, 1995

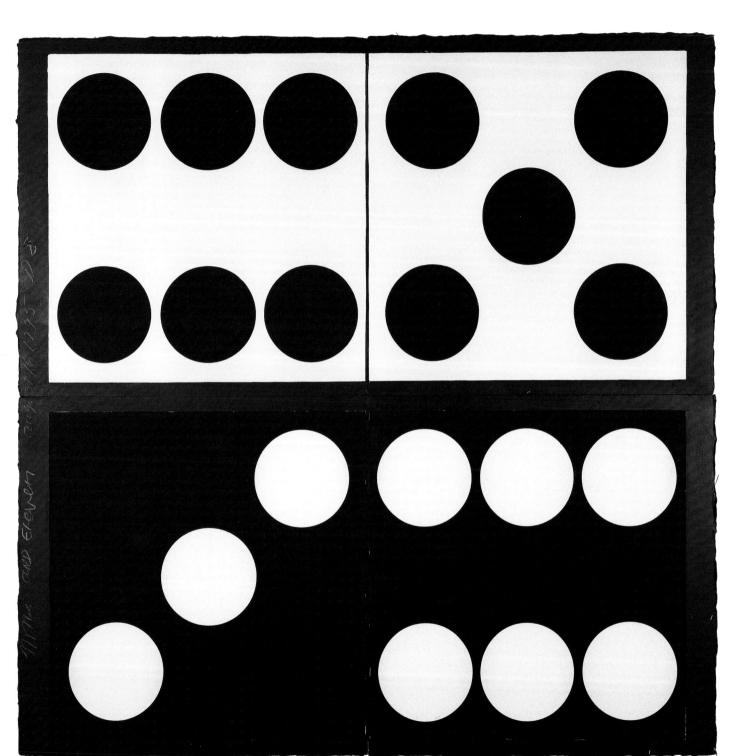

Black Button, April 3, 1997

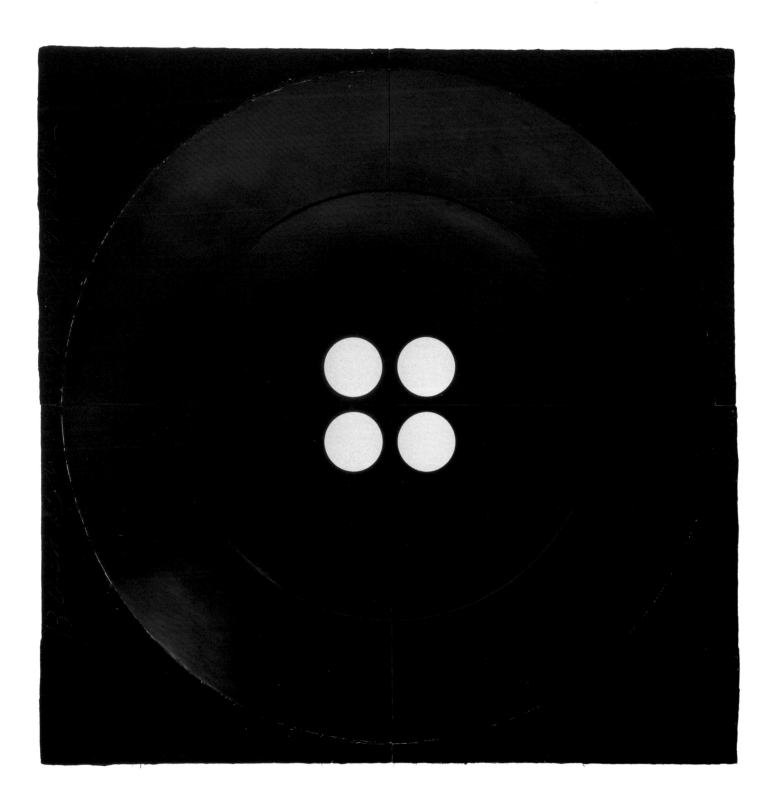

Black Egg and Tomatoes, August 4, 1998

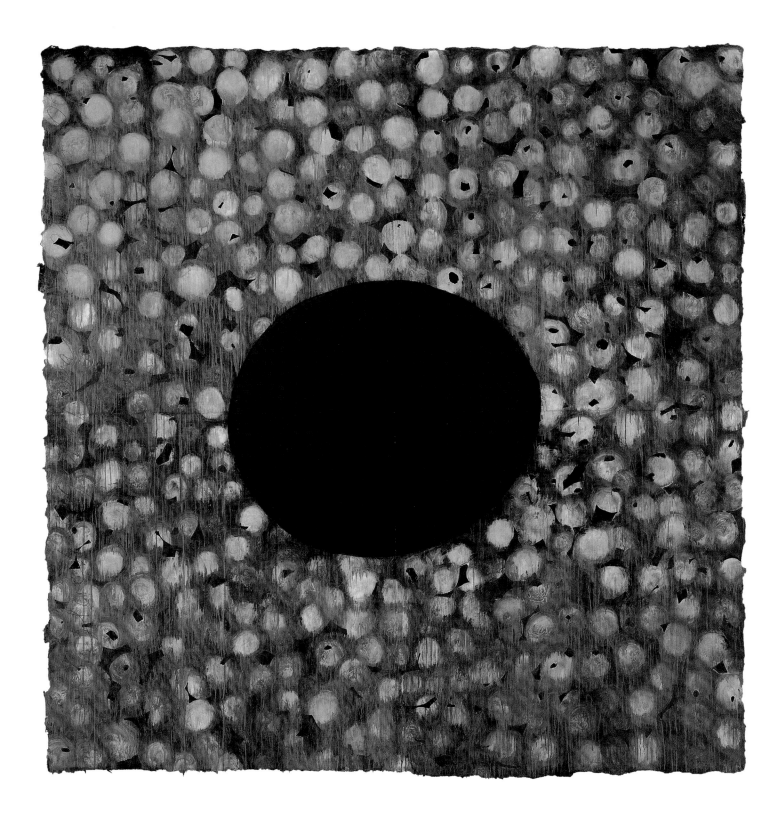

Black Eggs and Yellow Roses, February 25, 1999

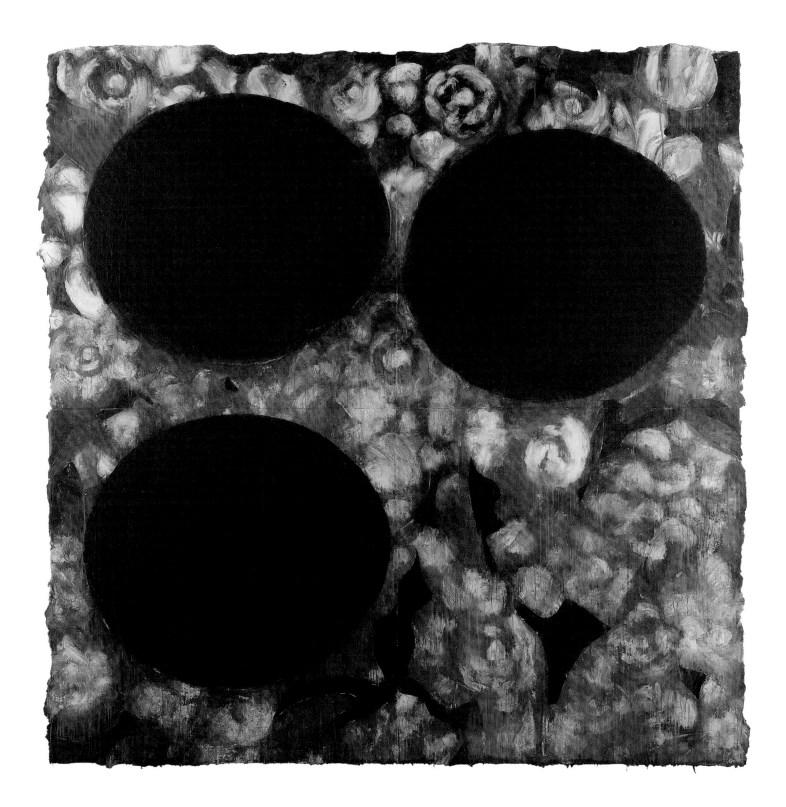

Checklist of the Exhibition

Lemon, November 28, 1983 (page 25)
Tar, oil, and plaster on linoleum over masonite
96 × 96 inches
Courtesy of The Eli Broad Family Foundation,
Santa Monica, Calif.

Four Lemons, February 1, 1985 (page 27)
Tar, oil, and plaster on linoleum over masonite
96 × 96 inches
Private Collection

Flowers and Vase, August 12, 1985 (page 29)
Tar, oil, and plaster on linoleum over masonite
96 × 96 inches
Collection of John and Sally Van Doren, Courtesy
of Greenberg Van Doren Gallery, St. Louis

Oranges, February 27, 1987 (page 31)
Tar, oil, and plaster on linoleum over masonite
96 × 96 inches
Private Collection, New York

Three Molding Limes and a Clementine, February 19, 1988
(page 33)
Tar, oil, and plaster on linoleum over masonite
96 × 96 inches
Private Collection

Matisse Flowers and Vase, September 23, 1988 (page 35)
Tar, oil, and plaster on linoleum over masonite
96 × 96 inches
Collection of Mrs. Susan Sultan, New York

Gladiolas in a Chinese Pot, December 2, 1988 (page 37)
Tar, oil, and plaster on linoleum over masonite
96 × 96 inches
Collection of Friends Seminary

Black Roses in a Black Rose Vase, February 2, 1990 (page 39)
Tar, oil, and plaster on linoleum over masonite
96 × 96 inches
Guild Hall Museum, East Hampton, N.Y.,
Gift of Donald Zucker

Domino, June 8, 1990 (page 41)
Tar, oil, and plaster on linoleum over masonite
96 × 96 inches
Private Collection

Hollyhock, January 17, 1991 (page 43)
Tar, oil, and plaster on linoleum over masonite
96 × 96 inches
Courtesy of Knoedler & Company, New York

Double Vase, March 11, 1992 (page 45)
Tar, oil, and plaster on linoleum over masonite
96 × 96 inches
Courtesy of Knoedler & Company, New York

Oranges in a Pot, April 5, 1993 (page 47)
Tar, oil, and plaster on linoleum over masonite
96 × 96 inches
Private Collection

Spike Acanthe, July 5, 1993 (page 49)
Tar, oil, and plaster on linoleum over masonite
96 × 96 inches
Collection of the Kemper Museum of Contemporary
Art, Kansas City, Mo.; Bebe and Crosby Kemper
Collection, Gift of the Enid and Crosby Kemper
Foundation, 1995

Stacked Dominos, October 28, 1994 (page 51)
Tar, oil, and plaster on linoleum over masonite
96 × 96 inches
Courtesy of Knoedler & Company, New York

Packed Vases, January 31, 1995 (page 53)
Tar, oil, and plaster on linoleum over masonite
96 × 96 inches
Courtesy of Knoedler & Company, New York

Four Buttons, July 29, 1995 (page 55)
Tar, oil, and plaster on linoleum over masonite
96 × 96 inches
Private Collection

Nine and Eleven, August 16, 1995 (page 57)
Tar, oil, and plaster on linoleum over masonite
96 × 96 inches
Private Collection

Black Button, April 3, 1997 (page 59)
Tar, oil, and plaster on linoleum over masonite
96 × 96 inches
Collection of Mr. and Mrs. James R. Patton, Jr.

Black Egg and Tomatoes, August 4, 1998 (page 61)
Tar, oil, and plaster on linoleum over masonite
96 × 96 inches
Courtesy of Knoedler & Company, New York

Black Eggs and Yellow Roses, February 25, 1999 (page 63)
Tar, oil, and plaster on linoleum over masonite
96 × 96 inches
Courtesy of Knoedler & Company, New York

Selected Biography

Selected One-Artist Exhibitions

1997 Janet Borden, New York: *Donald Sultan: Smoke Rings*

Galerie Daniel Templon, Paris

Greenberg VanDoren Gallery, St. Louis: *Donald Sultan: Flowers*

Knoedler & Company, New York: *Donald Sultan: Paintings and Drawings*

1998 Baldwin Gallery, Aspen, Colo.

Galerie Lutz & Thalmann, Zurich

Galleria Lawrence Rubin, Milan: *Donald Sultan: Recent Work*

Turner and Runyon Gallery, Dallas: *Donald Sultan: New Paintings and Drawings*

1999 The Jewish Museum, New York: *Bar Mitzvah* (book collaboration with playwright David Mamet)

Knoedler & Company, New York: *Donald Sultan: Recent Painting*

Meredith Long & Co., Houston: *Donald Sultan Recent Works*

Selected Group Exhibitions

1972 The Mint Museum of Art, Charlotte, N.C.: *36th Annual Student Exhibition*

1974 N.A.M.E. Gallery, Chicago: *George Liebert, Donald Sultan*

1977 New Museum of Contemporary Art, New York (organizing institution): *Four Artists: Drawing*. Traveled to Institute of Contemporary Art, Tokyo (catalogue)

1978 Mary Boone Gallery, New York: *Jean Feinberg, Lynn Hzkowitz, Donald Sultan*

Willard Gallery, New York: *Group Show*

1979 Whitney Museum of American Art, New York: *1979 Biennial Exhibition* (catalogue)

1980 Indianapolis Museum of Art: *Painting and Sculpture Today: 1980* (catalogue)

1981 Contemporary Arts Museum, Houston: *The Americans: The Landscape* (catalogue)

The Museum of Modern Art, New York: *Black and White*

1982 *20th Anniversary Exhibition of the Vogel Collection*. Traveled to Gallery of Art, University of Northern Iowa, Cedar Rapids; Brainerd Art Gallery, Potsdam, Germany (catalogue)

1983 Blum Helman Gallery, New York: *Steve Keister: Sculpture / Donald Sultan: Charcoals*

The Museum of Modern Art, New York: *Prints from Blocks—Gauguin to Now*

Palacio de Velazquez, Madrid: *Tendencias en Nueva York*. Traveled to Fundación Joan Miró, Barcelona; Musée du Luxembourg, Paris (catalogue)

1984 Artists Space, New York: *A Decade of New Art*

Kitakyushu Municipal Museum of Art, Japan: *Painting Now* (catalogue)

The Museum of Modern Art, New York: *An International Survey of Recent Painting and Sculpture*

Walker Art Center, Minneapolis: *Images and Impressions: Painters Who Print*. Traveled to Institute of Contemporary Art, University of Pennsylvania, Philadelphia (catalogue)

1985 Laforet Museum, Harajuku, Tokyo: *Correspondences: New York Art Now*. Traveled to Tochigi Prefectural Museum of Fine Arts, Utsunomiya, Japan

1986 The Brooklyn Museum: *Monumental Drawings: Work by 22 Contemporary Americans*

The Brooklyn Museum: *Public and Private: American Prints Today*. Traveled to Flint Institute of Art, Mich.; Rhode Island School of Design, Providence; Museum of Art, Carnegie Institute, Pittsburgh; Walker Art Center, Minneapolis (catalogue)

Galerie Adrien Maeght, Paris: *A Propos de dessin* (catalogue)

Museum of Fine Arts, Boston: *Boston Collects: Contemporary Painting and Sculpture*

1987 The Art Gallery of Ontario, Toronto: *Selections from the Roger and Myra Davidson Collection*

1988 The Solomon R. Guggenheim Museum, New York: *Viewpoints: Paintings and Sculpture from the Guggenheim Museum Collection and Major Loans*

1989 Galerie Montenay, Paris: *Nature morte*

Modern Art Museum of Fort Worth: *10 + 10: Contemporary American and Soviet Painters*. Traveled to San Francisco Museum of Modern Art; Albright-Knox Art Gallery, Buffalo; Milwaukee Art Museum; Corcoran Gallery of Art, Washington, D.C.; Artist's Union Hall of the Tretyakov Gallery Krymskaia Embankment, Moscow; Central Exhibition Hall, Leningrad (catalogue)

Whitney Museum of American Art at the Equitable Center, New York: *Nocturnal Visions in Contemporary Painting*

1990 Art Gallery of Ontario, Toronto: *Selections from the Roger and Myra Davidson Collection*

Stanford University Museum of Modern Art, Stanford, Calif.: *Sean Scully / Donald Sultan: Abstraction / Representation—Paintings, Drawings and Prints from the Anderson Collection*

1991 John Berggruen Gallery, San Francisco: *Large Scale Works on Paper* (catalogue)

Knoedler & Company, New York: *Works on Paper*

1992 Bibliothèque Nationale, Paris: *De Bonnard à Baselitz: Dix ans d'enrichissement du Cabinet des Estampes 1978–1988* (catalogue)

The Museum of Fine Arts, Houston: *Singular and Plural, Recent Accessions, Drawings & Prints 1945–1991*

1993 National Galerie, Berlin: *Wege der Moderne: Di Sammlung Beyeler (Ways of the Modern: From the Beyeler Collection)*

1994 Hill Gallery, Birmingham, Mich.: *Popular Culture*

Kemper Museum of Contemporary Art, Kansas City, Mo.: *Inaugural Exhibition*

1995 The Museum of Modern Art, New York: *Semblances*

National Museum of American Art, Smithsonian Institution, Washington, D.C.: *Recent Acquisitions of Paper*

Paine Webber Incorporated, New York (organizing institution): *The Paine Webber Art Collection*. Traveled to Detroit Institute of Arts; Museum of Fine Arts, Boston; Minneapolis Institute of Arts; San Diego Museum of Art; Center for the Fine Arts, Miami (catalogue)

1996 Knoedler & Company, New York: *Different Sides*

The Museum of Modern Art, New York: *Thinking Print—Books to Billboards 1980–1995*

1997 Baumgartner Galleries, Washington, D.C.: *New York on Paper*

Boston University Art Gallery: *Painting Machines, Industrial Image and Process in Contemporary Art*

Robert Brown Gallery, Washington, D.C.: *Floor to Ceiling: A Twentieth Century Print Salon*

Fotouhi Cramer Gallery, New York: *Edge of Chaos;* curated by John Torreano

Paul Kasmin Gallery, New York: *Summer*

Museum of Contemporary Art, San Diego: Exhibition of works from the permanent collection

1998 Arts on Douglas, New Smyrna Beach, Fla.: *Mirror Images*

The Jewish Museum, New York: *Contemporary Artists Welcome the New Year—The Jewish Museum List Graphic Commission*

Barbara Mathes Gallery, New York: Art Dealers Association of America, Art Show Benefit for the Henry Street Settlement

Elizabeth Mayer Fine Art, New York: *80's Artists Then and Now*

Selected Articles

"The Artful Traveler," *ArtNews*, Apr. 1997, p. 106.

Belcove, Julie L. "Sultan's Rule," *W*, Apr. 1997, pp. 172, 174.

Braff, Phyllis. "Donald Sultan Show Delivers a Substantial Impact," *New York Times*, Aug. 25, 1996, p. 12.

Cheever, Susan. "Donald Sultan's Soho Evolution: The Artist's Loft and Studio in Manhattan," *Architectural Digest*, Sept. 1993, pp. 116–21, 185.

Glueck, Grace. "Steve Keister and Donald Sultan," *New York Times*, Dec. 23, 1983, p. C22.

Henry, Gerrit. "Dark Poetry," *ArtNews*, Apr. 1987, pp. 104–11.

Karmel, Pepe. "Art in Review: Donald Sultan 'Wall Flowers'/Paul Kasmin Gallery," *New York Times*, Jan. 6, 1995, p. C24.

Kozik, K. K. "Industrial Strength" and "Donald Sultan Stresses the Materials," *Cover*, Mar. 1991, pp. 8, 9.

Larson, Kay. "Donald Sultan at Willard," *Village Voice*, Oct. 15, 1980.

Naves, Mario. "Donald Sultan" (review: Knoedler), *Tema Celeste*, summer 1992, p. 78.

Russell, John. "Donald Sultan," *New York Times*, Apr. 30, 1982, p. C234.

Smith, Roberta. "Review: Art, Long Island Shows—Small, Closely Focused and Odd," *New York Times*, Aug. 21, 1992, p. C22.

Tomkins, Calvin. "Clear Painting," *New Yorker*, June 3, 1985, pp. 106, 109–13.

Upshaw, Regan. "Donald Sultan at Knoedler," *Art in America*, Sept. 1995, p. 109.

Selected Books and Exhibition Catalogues

A Propos de dessin. Exh. cat. Paris: Galerie Adrien Maeght, 1985.

The Americans: The Landscape. Essay by Linda L. Cathcart. Exh. cat. Houston: Contemporary Arts Museum, 1981.

Coopersmith, Georgia. *20th Anniversary Exhibition of the Vogel Collection.* Introduction by Dorothy Vogel. Exh. cat. Potsdam, Germany: Brainerd Art Gallery, 1982.

De Bonnard à Baselitz: Estampes et livres d'artistes: Dix ans d'enrichissements du Cabinet des Estampes, 1978–1988. Essays by Françoise Woimant, Marie-Cecile Miessner, and Anne Moeglin-Delcroix. Exh. cat. Paris: Bibliothèque Nationale, 1992.

Donald Sultan. Essay by Maki Kuwayama. Exh. cat. Tokyo: Akira Ikeda Gallery, 1983.

Donald Sultan. Essay by William Zimmer. Exh. cat. New York: Blum Helman Gallery, 1984.

Donald Sultan. Exh. cat. Rome: Gian Enzo Sperone, 1985.

Donald Sultan. Exh. cat. London: Waddington Galleries, 1990.

Donald Sultan: Neue Arbeiten 1996. Exh. cat. Zurich: Galerie Lawrence Rubin, 1996.

Donald Sultan: Paintings. Exh. cat. New York: Knoedler & Company, 1990.

Donald Sultan: Paintings 1978–1992. Essay by Donald Kuspit. Exh. cat. East Hampton, N.Y.: Guild Hall Museum, 1992.

Donald Sultan: Pintures. Essay by Francisco Calvo Serraller. Exh. cat. Barcelona: Galeria Trama, 1992.

Donald Sultan: Playing Cards. Essays by David Mamet and Ricky Jay. Kyoto: Kyoto Shoin International, 1989.

Donald Sultan: Works on Paper. Exh. cat. London: Runkel-Hue-Williams, 1989.

Dunlop, Ian, and Lynne Warren. *Donald Sultan.* Exh. cat. Chicago: Museum of Contemporary Art; New York: Harry N. Abrams, 1987.

Goldwater, Marge. "Donald Sultan," in Martin Friedman et al., *Images and Impressions: Painters Who Print.* Exh. cat. Minneapolis: Walker Art Center, 1984.

1979 Biennial Exhibition. Exh. cat. New York: Whitney Museum of American Art, 1979.

Public and Private: American Prints Today. Essay by Barry Walker. Exh. cat. New York: Brooklyn Museum, 1986.

Ratcliff, Carter. *Visionary Images.* Exh. cat. Chicago: Renaissance Society at the University of Chicago, 1979.

Rose, Barbara. *Sultan: An Interview with Donald Sultan by Barbara Rose.* New York: Vintage Books, 1988.

Sergeant, Philippe. *Donald Sultan: Appoggiatures.* Paris: Editions de la Différence, 1989. English ed.: trans. Joachim Neugroschel, New York: Portmanteau Press, 1992.

10 + 10: Contemporary American and Soviet Painters. Ed. Irina Bulgakova; trans. Jamey Gambrell. Exh. cat. New York: Harry N. Abrams; Leningrad: Aurora, 1989.

Tendencias en Nueva York. Essays by Eric Fischl and Carmen Gimenez. Exh. cat. [Spain]: Ministerio de Cultura, Direccion General de Bellas Artes y Archivos, Subdireccion General de Artes Plasticas, 1983.

Tucker, Marcia. *Four Artists: Drawing.* Interview by Michiko Miyamoto. Exh. cat. New York: New Museum of Contemporary Art, 1977.

Walker, Barry. *Donald Sultan: A Print Retrospective.* Exh. cat. New York: American Federation of Arts in association with Rizzoli, 1992.

Selected Public Collections

The Ackland Art Museum, University of North Carolina, Chapel Hill

Addison Gallery of American Art, Andover, Massachusetts

Albright-Knox Art Gallery, Buffalo

The Arkansas Art Center, Little Rock

The Art Institute of Chicago

Art Museum of Southeast Texas, Beaumont

Australian National Gallery, Canberra

Bank America Corporation

Butler Institute of American Art, Youngstown, Ohio

Cincinnati Art Museum

Dallas Museum of Art

Des Moines Art Center

Fogg Art Museum, Harvard University, Cambridge, Massachusetts

The High Museum of Art, Atlanta

Hirshhorn Museum and Sculpture Garden, Smithsonian Institution, Washington, D.C.

Kemper Museum of Contemporary Art, Kansas City, Missouri

Kitakyushu Municipal Museum of Art, Tobataku Kitakyushu, Japan

The Metropolitan Museum of Art, New York

Modern Art Museum of Fort Worth, Texas

The Museum of Fine Arts, Boston

The Museum of Fine Arts, Houston

The Museum of Modern Art, New York

Nelson-Atkins Museum, Kansas City, Missouri

Neuberger Museum, State University of New York

North Carolina Museum of Art, Raleigh

The Saint Louis Art Museum

San Diego Museum of Contemporary Art, La Jolla, California

San Francisco Museum of Modern Art

Smith College, Museum of Art, Northampton, Massachusetts

The Solomon R. Guggenheim Museum, New York

The Toledo Museum of Art

Walker Art Center, Minneapolis

Whitney Museum of American Art, New York

71

Photograph Credits

Photographs of works of art have been supplied in many cases by the owners or custodians of the works, identified in the captions. The following list applies to photographs for which a separate acknowledgment is due.

Black Egg and Tomatoes, August 4, 1998: John Black

Four Lemons, February 1, 1985; Flowers and Vase, August 12, 1985; Oranges, February 27, 1987; Matisse Flowers and Vase, September 23, 1988; Gladiolas in a Chinese Pot, December 2, 1988; Black Roses in a Black Rose Vase, February 2, 1990; Domino, June 8, 1990: Ken Cohen

Packed Vases, January 31, 1995: Deschenes

Still Life with Glass and Lemon, 1972 by Roy Lichtenstein: Courtesy of The Helman Collection, New York; photograph by Erma Estwick, courtesy of Joseph Helman Gallery, New York

Lemons, April 9, 1984: courtesy of Knoedler & Company, New York

Lemon, November 28, 1983: Douglas M. Parker

Hollyhock, January 17, 1991; Double Vase, March 11, 1992; Stacked Dominos, October 28, 1994; Black Button, April 3, 1997; Black Eggs and Yellow Roses, February 25, 1999: Eddie Watkins

Oranges in a Pot, April 5, 1993; Spike Acanthe, July 5, 1993; Four Buttons, July 29, 1995; Nine and Eleven, August 16, 1995: Zindman/Fremont